COOL SHOPS
HAMBURG

teNeues

Imprint

Editor: Camilla Péus

Editorial coordination: Lea Bauer

Location scouting: Ariane Alber, Camilla Péus

Photos (location): Martin Luther (Alsterhaus, page 10), Pieter P. Rupprecht (Alsterhaus), courtesy Bettina Schoenbach Design GmbH (Bettina Schoenbach Showroom, pages 22, 24, 25), Birgit Hübner (Buchhandlung im Haus der Photogaphie), Schnuppe von Gwinner (craft2eu), Daniel Josefsohn / C.L. / Steffus Mayr (DIESEL), Klaus Frahm (Ermenegildo Zegna), Franziska Krug (Flamant), Torsten Kollmer (Grüne Flora, page 60), Matthias Glage (Hamburger Hof Parfümerie), Volker Strey (Linette), courtesy Louis Vuitton (Louis Vuitton), Petra Teufel (Petra Teufel), Bettina Lewin (Thorsten Lewin). All other photos by Roland Bauer.

Introduction: Camilla Péus

Layout: Kerstin Graf, papierform

Imaging & Pre-press: Jan Hausberg

Translations: SAW Communications, Dr. Sabine A. Werner, Mainz
Dr. Suzanne Kirkbright (English), Brigitte Villaumié (French), Silvia Gómez de Antonio (Spanish), Maria-Letizia Haas (Italian)

Produced by fusion publishing GmbH, Stuttgart . Los Angeles www.fusion-publishing.com

Published by teNeues Publishing Group

teNeues Book Division
Kaistraße 18
40221 Düsseldorf, Germany
Tel.: 0049-(0)211-994597-0
Fax: 0049-(0)211-994597-40
E-mail: books@teneues.de

teNeues France S.A.R.L.
4, rue de Valence
75005 Paris, France
Tel.: 0033-1-55766205
Fax: 0033-1-55766419

teNeues Publishing Company
16 West 22nd Street
New York, NY 10010, USA
Tel.: 001-212-627-9090
Fax: 001-212-627-9511

teNeues Ibérica S.L.
c/Velázquez, 57 6.° izda.
28001 Madrid, Spain
Tel.: 0034-657-132133

teNeues Publishing UK Ltd.
P.O. Box 402
West Byfleet
KT14 7ZF, Great Britain
Tel.: 0044-1932-403509
Fax: 0044-1932-403514

teNeues
Representative Office Italy
Via San Vittore 36/1
20123 Milan
Tel.: 0039-(0)347-7640551

Press department: arehn@teneues.de
Phone: 0049-2152-916-202

www.teneues.com

ISBN-10: 3-8327-9120-5
ISBN-13: 978-3-8327-9120-9

© 2006 teNeues Verlag GmbH + Co. KG, Kempen

Printed in Italy

Picture and text rights reserved for all countries.
No part of this publication may be reproduced in any manner whatsoever.

All rights reserved.

While we strive for utmost precision in every detail, we cannot be held responsible for any inaccuracies, neither for any subsequent loss or damage arising.

Bibliographic information published by Die Deutsche Bibliothek.
Die Deutsche Bibliothek lists this publication in the Deutsche Nationalbibliografie;
detailed bibliographic data is available in the Internet at http://dnb.ddb.de.

Contents	Page
Introduction	5
Alsterhaus	10
Andreas Linzner	16
Bethge Hamburg	20
Bettina Schoenbach Showroom	22
Bettina Schoenbach Store	26
Buchhandlung im Haus der Photographie	28
Cape Grace	30
craft2eu	32
DIESEL	34
Die Wäscherei	36
Elternhaus	42
Ermenegildo Zegna Shop Hamburg	46
Feldenkirchen – Men	48
Flamant	50
Frank Otto	52
Frischeparadies **Goedeken**	56
Grüne Flora	58
Hamburger Hof Parfümerie	62
Harald Lubner	64
Herr von Eden	66
Kuball&Kempe	70
Linette	74
Louis Vuitton	78
Marc Anthony Maß und Maßkonfektion	80
Montblanc	84
Olaf Thomas	90
Oschätzchen	94
Petra Teufel	98
Roomservice	100
Salon	104
T.A.T.E. tough against the elements	110
Tempel	112
Thorsten Lewin	116
Trittmacher	118
tulpen.design	120
Unger	124
Uniono by Shoes	128
Xocolaterie	130
Map	134

4

Introduction

Hamburg is a trend-setting city. In the city districts of this metropolis on the Elbe, where all districts have a distinctive character, a colorful mixture of chic fashion boutiques, interiors stores and design studios is established with a magical power of attraction over city-dwellers and visitors alike.

From small treasure troves, where an initiated and experienced group rummage for precious items, to accessible and complete works of art, where the avant-garde style of the store design reflects the unique selection of the goods: everything is gathered in Hamburg—no matter whether it's emphatically minimalist or non-Hanseatic opulent.

The Schanzen district, including the Marktstraße, has especially transformed itself from ugly duckling to dazzling swan. Once historic and crumbling buildings today display finely restored façades. Streets, squares and cafés are a rendez-vous for residents, trendy people and tourists. Anybody who loves individuality and exploits his creative potential has settled here: young designers create bespoke evening gowns, fashion shops present exclusive labels for the sophisticated fashion scene and a small manufacturer offers everything, from hand towels to cuddly animals, made out of toweling. The innovative concepts and cleverly staged offers are clearly distinguished from mainstream products of major city chains.

Interiors stores display international brands as well as 1970's classics. At the same time, they provide a forum for a new generation of designers where you can go on a voyage of discovery. The same is true of the new chocolatiers that present their delicious creations in retro-styled displays and the concept stores, where Meißen porcelain is right next to exclusive sneakers by Adidas.

This book includes over 30 shops, whose styling and product range points to the future, because the shops in Hamburg are primarily designed with one goal: to be unmistakable instead of only to present a display floor and podium for clothes, furniture, design, books and delicatessen goods. That is the big city pure!

Camilla Péus

Einleitung

Hamburg setzt Trends. In den Stadtvierteln der Elbmetropole, die alle ihren eigenen Charakter haben, hat sich eine bunte Mischung von schicken Modeboutiquen, Einrichtungsläden und Designateliers etabliert, die eine magische Anziehungskraft auf Bewohner und Besucher gleichermaßen ausüben.
Von kleinen Schatzkisten, wo Insider mit geschultem Blick Kostbarkeiten aufstöbern, bis hin zu begehbaren Gesamtkunstwerken, wo die avantgardistische Ladengestaltung die einzigartige Auswahl der Waren widerspiegelt. In Hamburg ist alles versammelt – ganz gleich ob betont minimalistisch oder unhanseatisch opulent.
Besonders das Schanzenviertel mit der Marktstraße hat sich vom grauen Entlein zum schillernden Pfau gewandelt. Einst bröckelnde Altbauten zeigen heute topp sanierte Fassaden. Straßen, Plätze und Cafés sind Treffpunkte für Anwohner, Szenevolk und Touristen. Hier hat sich angesiedelt, wer Individualität liebt und sein kreatives Potential auslebt: Jungdesigner schneidern Abendroben nach Maß, Modeshops präsentieren ausgesuchte Marken für die anspruchsvolle Fashion-Szene und eine kleine Manufaktur bietet vom Handtuch bis zum Kuscheltier alles aus Frottier. Die neuartigen Konzepte und raffiniert inszenierten Angebote heben sich deutlich vom Mainstream der Großstadtketten ab.
Interieurläden zeigen internationale Marken sowie Klassiker aus den 70er-Jahren. Gleichzeitig bieten sie Foren für Nachwuchsdesigner, in denen man auf Entdeckungsreise gehen kann. Ebenso wie in den neuen Chocolaterien, die ihre köstlichen Kreationen in Retro-Vitrinen präsentieren und den Conceptstores, wo Meißner Porzellan neben Edel-Sneakers von Adidas liegt.
Dieses Buch versammelt über 30 Shops, deren Styling und Angebot in die Zukunft weisen, denn die Gestaltungen der Hamburger Läden haben vor allem ein Ziel: Statt nur Auslagefläche und Podest für Kleider, Möbel, Design, Bücher und Delikatessen zu sein, machen sie sich unverwechselbar. Das ist Großstadt pur!

Camilla Péus

Introduction

Hambourg est la ville des tendances. Dans les quartiers de la métropole sur l'Elbe qui possèdent tous leur propre cachet, il s'est installé un mélange bigarré de boutiques de mode, de magasins de décoration et d'ateliers de design chic qui exercent une force d'attraction magique aussi bien sur les habitants que sur les visiteurs.
Des magasins semblables à des coffrets au trésor où les initiés dénichent d'un œil de connaisseur des objets de valeur aux magasins de type « chef œuvre d'art total » dont l'aménagement avant-gardiste reflète le choix extraordinaire des articles: on trouve tout à Hambourg – un style volontairement minimaliste aussi bien qu'une opulence contraire à l'austérité hanséatique.
Notamment le Schanzenviertel avec la Marktstrasse qui, de vilain petit canard, s'est métamorphosé en paon scintillant. Des bâtiments anciens jadis décrépits affichent aujourd'hui des façades parfaitement rénovées. Les rues, les places et les cafés sont le point de rencontre des résidents, des branchés et des touristes. Ici se sont installés ceux qui aiment l'individualité et vivent à fond leur potentiel créatif: de jeunes créateurs réalisent des robes du soir sur mesure, des boutiques de mode présentent des marques sélectives pour l'exigeante scène de la mode et une petite manufacture propose tout en tissu éponge, de la serviette de bain à l'animal en peluche. Les concepts innovateurs et les offres à la mise en scène raffinée se démarquent nettement de la normalité des chaînes de grands magasins.
Les magasins de décoration intérieure présentent des marques internationales ainsi que des classiques des années 70. Simultanément ils servent de forum à une nouvelle génération de créateurs au sein desquels on peut partir à la découverte. Tout comme dans les nouvelles chocolateries qui présentent leurs délicieuses créations dans des vitrines rétro ou dans les conceptstores où la porcelaine de Meißner voisine avec de beaux sneakers Adidas.
Ce livre réunit plus de 30 boutiques dont le styling et l'offre sont orientés vers l'avenir. En effet, la conception des magasins hambourgeois veut, avant tout, être impossible à confondre, plutôt que d'être une simple surface d'exposition et une estrade pour les vêtements, les meubles, le design, les livres et les produits fins. C'est l'esprit « grande ville ».

Camilla Péus

Introducción

Hamburgo crea tendencias. En los barrios con carácter propio de esta metrópoli a orillas del Elba se ha establecido una colorida mezcla de elegantes boutiques de ropa, tiendas de interiorismo y talleres de diseñadores, que ejerce una mágica atracción sobre los habitantes de la ciudad y los visitantes.
Desde pequeños tesoros donde la mirada experta de los entendidos se encuentra con joyas, hasta transitables obras de arte totales donde el diseño vanguardista del interior refleja la exclusiva selección de los productos. En Hamburgo está todo reunido, tanto lo pronunciadamente minimalista como la opulencia impropia del carácter hanseático.
El Schanzenviertel con la Marktstraße se ha transformado de patito feo en irisado pavo real. Los edificios antiguos, otrora desmoronados, muestran hoy fachadas completamente saneadas. Las calles, las plazas y los cafés son el punto de encuentro de los habitantes, de la movida cultural y de los turistas. Aquí se han establecidos los que aman la individualidad y exteriorizan su potencial creativo: jóvenes diseñadores confeccionan trajes de noche a medida, las tiendas de ropa presentan marcas exclusivas para los amantes de la moda y una pequeña empresas ofrece desde toallas hasta peluches, todo en tejido de rizo. Los conceptos novedosos y los productos presentados con sofisticación se distinguen claramente de los artículos convencionales propios de las cadenas de las grandes ciudades.
Las tiendas de interiorismo muestran marcas internacionales y clásicos de la década de 1970. Al mismo tiempo ofrecen foros para los nuevos diseñadores donde se pueden realizar viajes de descubrimiento. Igual que en las nuevas chocolaterías, que presentan sus deliciosas creaciones en vitrinas de estilo retro, y en las concept stores, donde la porcelana de Meißner está colocada al lado de las elegantes zapatillas de deporte de Adidas.
Este libro reúne más de 30 tiendas cuyo estilo y oferta muestran el camino hacia el futuro, y es que el diseño de las tiendas de Hamburgo tiene sobre todo un objetivo: dejar de ser meras exposiciones y escaparates de ropa, muebles, diseño y exquisiteces, para convertirse en algo inconfundible. ¡Esto es una metrópoli en estado puro!

Camilla Péus

Introduzione

Amburgo fa tendenza. Nei quartieri della metropoli sulle rive dell'Elba, ognuno con un proprio carattere ben definito, si è stabilita una miriade variopinta di eleganti boutique, negozi d'arredamento e studi di design che esercitano un'attrazione magica sia sugli abitanti sia sui turisti.
Si va da quelli che sono veri e propri scrigni di tesori, in cui gli insider scovano rarità con colpo d'occhio sicuro, alle opere d'arte totali accessibili, in cui l'organizzazione d'avanguardia rispecchia la selezione unica degli articoli. Ad Amburgo si trova di tutto – non importa se di stampo prettamente minimalista o, in contrasto con lo stile anseatico, di gusto ricco ed opulento.
Soprattutto lo Schanzenviertel, con la Marktstraße, si è trasformato da brutto anatroccolo a splendido cigno: i vecchi edifici fatiscenti di un tempo mostrano oggi facciate finemente ristrutturate. Le strade, le piazze ed i caffè costituiscono un punto d'incontro per gli abitanti, il jet-set ed i turisti. È qui che vive chi ama l'individualità ed estrinseca il proprio potenziale creativo: giovani designer confezionano abiti da sera su misura, negozi alla moda propongono marche esclusive per soddisfare i gusti ricercati della clientela fashion ed una piccola manifattura offre – dall'asciugamano al teddy bear – una moltitudine di articoli in spugna. L'innovazione delle idee e la raffinatezza con cui i prodotti vengono proposti si distinguono notevolmente dall'offerta convenzionale delle catene di negozi delle grandi città.
Gli studi d'arredamento d'interni espongono sia marche internazionali sia pezzi classici degli anni settanta, e propongono, nello stesso tempo, forum per giovani designer in cui il cliente può andare alla scoperta di mille idee. Lo stesso avviene nelle nuove chocolaterie, che presentano le loro squisite creazioni in vetrine di stile retro, e nei conceptstore, in cui porcellane di Meißner fanno bella mostra di sé accanto a sneaker Adidas di lusso.
Questo libro è una raccolta di più di 30 negozi il cui styling e la cui offerta guardano al futuro. La configurazione dei negozi di Amburgo ha, infatti, soprattutto un obiettivo: invece di limitarsi ad essere superficie di esposizione e cornice per abiti, mobili, design, libri e leccornie, essi si rendono inconfondibili: è questa l'essenza di una vera metropoli!

Camilla Péus

Subway: Jungfernstieg
Opening hours: Mon–Sat 10 am to 8 pm
Special features: Restaurant in the 4th floor

ALSTERHAUS

10 | Alsterhaus

Alsterhaus | 11

Alsterhaus

Alsterhaus | 13

Alsterhaus

Alsterhaus | 15

Andreas Linzner

Design: Andreas Linzner

Marktstraße 6 | 20357 Hamburg | Karoviertel
Phone: +49 40 43 34 35
www.andreaslinzner.com
Subway: Feldstraße, Messehallen
Opening hours: Mon–Fri noon to 7 pm, Sat 11 am to 5 pm
Products: Terry towel and accessories made by toweling—a fabric dreams are made of: soft, fluffy and comfortable

Andreas Linzner | 17

18 | Andreas Linzner

Andreas Linzner | 19

Bethge Hamburg

Design: Alexander C. Martin

Hohe Bleichen 25 | 20354 Hamburg | Center
Phone: +49 40 31 15 52
www.bethge-hamburg.de
Subway: Jungfernstieg
Opening hours: Mon–Fri 10 am to 7 pm, Sat 10 am to 6 pm
Products: Writing instruments and accessories, special design

Bethge Hamburg | 21

Bettina Schoenbach
Showroom

Design: Hadi Teherani

Lofthaus am Elbberg 1 | 22767 Hamburg | Altona
Phone: +49 40 89 70 07 78
www.bettinaschoenbach.com
Subway: Fischmarkt
Opening hours: Mon–Fri 10 am to 6 pm
Products: Womens apparel, handbags, accessories, books
Special features: Monthly events

Bettina Schoenbach Showroom

Bettina Schoenbach Showroom | 25

Bettina Schoenbach
Store

Design: Bettina Schoenbach Team

Maria-Louisen-Straße 2a | 22301 Hamburg | Winterhude
Phone: +49 40 42 91 64 72
www.bettinaschoenbach.com
Subway: Winterhude
Opening hours: Mon–Fri 10 am to 6 pm, Sat 10 am to 4 pm
Products: Womens apparel, handbags, accessories, books
Special features: Monthly events

Bettina Schoenbach Store | **27**

Buchhandlung
im Haus der Photographie

Design: Jan Störmer Partner

Deichtorstraße 1-2 | 20095 Hamburg | Mitte
Phone: +49 40 32 52 87 04
www.deichtorhallen.de
Subway: Steinstraße, Hauptbahnhof
Opening hours: Tue–Sun 11 am to 6 pm, Mon closed
Products: Very extensive assortment concerning photography
Special features: Regular events with book-signings, book-presentations and conversation with artists

Buchhandlung im Haus der Photographie

Subway: Sierichstraße
Opening hours: Tue–Fri 10 am to 1 pm, Thu–Fri 3 pm to 6 pm
Products: Modern interior design and accessories from South Africa
Special features: Regular "Ladies' Teatime"

30 | Cape Grace

craft2eu

Design: Philipp von Gwinner

Eppendorfer Weg 231 | 20251 Hamburg | Eppendorf
Phone: +49 40 48 09 28 22
www.craft2eu.net
Subway: Hoheluftbrücke, Eppendorfer Baum
Opening hours: Mon–Fri noon to 7 pm, Sat 11 am to 4 pm
Products: European artcraft and design in fashion and interior
Special features: 4 to 6 special subject exhibitions a year; special collection of contemporary British automatas

craft2eu | 33

DIESEL

Design: DIESEL

Poststraße 14/16 | 20354 Hamburg | Center
Phone: +49 40 35 00 47 10
www.diesel.com
Subway: Jungfernstieg
Opening hours: Mon–Sat 11 am to 8 pm
Products: Fashion and denim female/male, accessories, footwear

Die Wäscherei

Design: Michael Eck

Jarrestraße 58 | 22303 Hamburg | Barmbek
Phone: +49 40 2 71 50 70
www.die-waescherei.de
Subway: Saarlandstraße
Opening hours: Mon–Fri 10 am to 8 pm, Sat 10 am to 6 pm
Products: Multifacted furniture, international press, books, flowers etc.
Special features: 6000 m² on 3 levels, DJ on Saturday, restaurant in the shop

Die Wäscherei | 37

38 | Die Wäscherei

Die Wäscherei | **39**

40 | Die Wäscherei

Die Wäscherei

Elternhaus

Design: Künstlergruppe Elternhaus

Marktstraße 29 | 20357 Hamburg | Karoviertel
Phone: +49 40 4 30 88 30
www.elternhaus.com
Subway: Messehallen
Opening hours: Mon–Sat noon to 6 pm
Products: Clothing for reanimating the contradiction

Elternhaus | 43

Elternhaus | 45

Ermenegildo Zegna
Shop Hamburg

Design: Gianmaria & Roberto Beretta, Bernd Leusmann

Neuer Wall 44 | 20354 Hamburg | Center
Phone: +49 40 2 98 13 60
www.zegna.com
Subway: Jungfernstieg
Opening hours: Mon–Sat 10 am to 8 pm
Products: Luxury men's fashion

Feldenkirchen – Men

Design: Andreas Feldenkirchen

Neue ABC-Straße 6 | 20354 Hamburg | Center
Phone: +49 40 34 05 71 76
www.feldenkirchen.de
Subway: Gänsemarkt, Jungfernstieg
Opening hours: Mon–Fri 11 am to 7 pm, Sat 11 am to 6 pm
Products: Hip and trendy denim, Etro, Rogan, Edun

Feldenkirchen – Men | **49**

Flamant

Hohe Bleichen 24 | 20354 Hamburg | Center
Phone: +49 40 3 34 41 80
www.flamant.com
Subway: Jungfernstieg
Opening hours: Shop: Mon–Fri 10 am to 7 pm, Sat 10 am to 6 pm
Café: Mon–Sat 10 am to 8 pm
Products: Furniture home and garden, home accessories
Special features: Café Flamant serving breakfast, lunch and coffee/tea. Interior projects with Flamant interior architect

Flamant | 51

Frank Otto

Design: Frank Otto

Gänsemarkt 24 | 20354 Hamburg | Neustadt
Phone: +49 40 35 71 54 87
www.frankottoliving.de
Subway: Gänsemarkt
Opening hours: Mon–Sat 10 am to 8 pm
Products: Furnitures accessories
Special features: Selling whole concepts, from paint to handbag

Frank Otto | 53

54 | Frank Otto

Frank Otto | 55

Frischeparadies **Goedeken**

Design: Robert Neuhaus Architekten

Große Elbstraße 210 | 22767 Hamburg | Altona
Phone: +49 40 38 90 80
www.frischeparadies.de
Subway: Königstraße
Opening hours: Mon–Fri 8 am to 7 pm, Sat 10 am to 3 pm
Products: Fresh and exhalted eatables from all over the world

Frischeparadies Goedeken | 57

Grüne Flora

Design: Karen Marx, Gert Lübs, Georg Klümpen

Schulterblatt 79 | 20357 Hamburg | Schanzenviertel
Phone: +49 40 21 97 99 33
Subway: Sternschanze, Feldstraße
Opening hours: Mon–Fri 10 am to 6:30 pm, Sat 10 am to 5 pm, Tue closed
Products: (Garden) plants, flowers, vases and home decoration

Grüne Flora | 59

60 | Grüne Flora

Grüne Flora | 61

Hamburger Hof
Parfümerie

Design: Herr Dee

Jungfernstieg 26 | 20354 Hamburg | Center
Phone: +49 40 34 96 04 21
Subway: Jungfernstieg
Opening hours: Mon–Sat 10 am to 7 pm
Products: Ca. 30.000 different exclusive products from all over the world

Hamburger Hof Parfümerie | 63

Products: Very extraordinary fragrances for body and room

64 | Harald Lubner

Harald Lubner | 65

Herr von Eden

Design: Herr von Eden

Marktstraße 33 | 20357 Hamburg | Center
Phone: +49 40 4 39 00 57
www.herrvoneden.com
Subway: Feldstraße, Messehallen
Opening hours: Mon–Fri 11 am to 8 pm, Sat 11 am to 6 pm
Products: Own collection of high-quality suits, shirts, neckties and accessories

68 | Herr von Eden

Herr von Eden | 69

Kuball&Kempe

Design: Peter Kempe, Thomas Kuball

Alter Fischmarkt 11 | 20457 Hamburg | Center
Phone: +49 40 30 38 22 00
Subway: Jungfernstieg, Rathausmarkt
Opening hours: Mon–Fri 10 am to 6 pm, Sat 10 am to 4 pm
Products: Everything concerning the beautiful life
Special features: Very personal touch, run by owners, modern interpretation of re-editons and especially for and by Kuball&Kempe-created Meißen porcelain

Kuball&Kempe

Kuball&Kempe | 73

Opening hours: Mon–Sat 10 am to 7 pm
Products: Best women's designer fashion, culti products, music
Special features: Special events like trunkshows, midnightshopping, creative window decorations

Linette | 75

Linette | 77

Louis Vuitton

Design: Peter Marino

Neuer Wall 37 | 20354 Hamburg | Center
Phone: +49 40 34 47 40
www.vuitton.com
Subway: Jungfernstieg
Opening hours: Mon–Fri 10 am to 7 pm, Sat 10 am to 6 pm
Products: Prêt-a-porter fashion for women and men, shoes, handbags, accessories

Louis Vuitton | 79

Products: Tailor-made suits and evening dresses
Special features: Charity fashion shows

80 | Marc Anthony Maß und Maßkonfektion

82 | Marc Anthony Maß und Maßkonfektion

Marc Anthony Maß und Maßkonfektion | 83

Montblanc

Design: Jean Michel Wilmotte

Neuer Wall 18 | 20354 Hamburg | Center
Phone: +49 40 35 11 75
www.montblanc.com
Subway: Jungfernstieg
Opening hours: Mon–Fri 10 am to 8 pm, Sat 10 am to 6 pm
Products: High-end luxury writing instruments, precious watches, exciting leather goods and lovely jewelry
Special features: Multilingual sales team, perfect after sales service

Montblanc | 85

Montblanc

Montblanc | 87

Montblanc

Olaf Thomas

Design: Olaf Thomas, Franck Doucet

Milchstraße 21 | 20148 Hamburg | Harvestehude
Phone: +49 40 41 35 27 62
Subway: Hallerstraße
Opening hours: Mon–Fri 11 am to 6 pm, Sat 10 am to 2 pm
Products: French antiquities from the 18th, 19th and 20th centuries, modern design

Olaf Thomas | 91

Olaf Thomas | 93

Oschätzchen

Design: Adrianna Koziewicz, Peter Oschätzchen

Hohe Bleichen 26 | 20354 Hamburg | Center
Phone: +49 40 35 00 47 80
www.oschaetzchen.com
Subway: Jungfernstieg
Opening hours: Mon–Fri 10 am to 7 pm, Sat 10 am to 6 pm
Products: Delicacies, spices and confiserie

Oschätzchen | 95

Oschätzchen | 97

Petra Teufel

Design: Kleffel & Köhnholdt

Neuer Wall 43 | 20354 Hamburg | Center
Phone: +49 40 37 86 16 20
www.petrateufel.de
Subway: Jungfernstieg, Rathaus
Opening hours: Mon–Fri 10 am to 7 pm, Sat 11 am to 6 pm
Products: Women and men RTW-Collection
Special features: Fragrances like Comme des Garçons, Paul Smith and cosmetics by Tocca, Sharpes etc., music, books and special events

Petra Teufel | 99

Products: Art interior design

Roomservice

102 | Roomservice

Salon

Design: Martina Herbolzheimer, Felicitas Bachmann

Jungfrauenthal 3 | 20149 Hamburg | Eppendorf
Phone: +49 40 4 80 08 03
www.salon-hamburg.de
Subway: Klosterstern, Eppendorfer Baum
Opening hours: Mon–Fri 10 am to 7 pm, Sat 10 am to 4 pm
Products: Cocktail, evening and wedding dresses, shoes, jewelry, handbags

Salon | 105

Salon | 109

T.A.T.E.
tough against the elements
Design: Thomas Friese

Gänsemarkt 24 | 20354 Hamburg | Center
Phone: +49 40 3 55 10 30
www.kunoichi-clothing.com
Subway: Gänsemarkt
Opening hours: Mon–Fri 10 am to 8 pm, Sat 10 am to 6 pm
Products: Men's and women's wear, shoes, accessories
Special Feature: Labels from around the world

T.A.T.E. | 111

Neuer Wall 64 | 20354 Hamburg | Center
Phone: +49 40 37 50 27 87
Subway: Jungfernstieg
Opening hours: Mon–Fri 11 am to 8 pm, Sat 10 am to 6 pm
Products: Fashion men & women, living accessories
Special Feature: More than 100 brands

Tempel | 113

114 | Tempel

Tempel | 115

Thorsten Lewin

Design: Thorsten Lewin

Rambachstraße 12 | 20459 Hamburg | Center
Phone: +49 40 3 70 06 60
www.lewin-hamburg.de
Subway: Baumwall
Opening hours: Tue–Fri 11 am to 7 pm, Sat 11 am to 4 pm
Products: Tailor-made suits and shirts for men, neckties, cuff links, traveling bags, accessories

Thorsten Lewin | 117

Trittmacher

Design: Dipl. Des. Sandra Thomsen

Colonnaden 72 | 20354 Hamburg | Center
Phone: +49 40 31 70 00 66
www.blumenbinder.com
Subway: Stephansplatz
Opening hours: Mon–Fri 8 am to 7:30 pm, Sat 11 am to 7 pm
Products: Floristics for weddings, funerals, mourning, bouquets, furniture

Trittmacher | 119

Opening hours: Mon–Fri 10 am to 7 pm, Sat 10 am to 4 pm
Products: Couture and exclusive night robes

120 | tulpen.design

tulpen.design | 121

tulpen.design | 123

Special features: U-Fleet is the groundfloor with trendy fashion labels and a constantly updated denim section

JIL SANDER

Unger | 127

Uniono by Shoes

Design: Stefan Sass / LANCELOT

Gertigstraße 17-19 | 22529 Hamburg | Winterhude
Phone: +49 40 27 87 66 69
www.musterlocation.com
Subway: Mühlenkamp
Opening hours: Mon–Sat 10 am to 7 pm
Products: Designer women's clothes

Uniono by Shoes

Xocolaterie

Design: Christoph Huber

Gertigstraße 11 | 22303 Hamburg | Winterhude
Phone: +49 40 27 80 77 92
www.xocolaterie.de
Subway: Mühlenkamp
Opening hours: Mon–Fri 10:30 am to 7 pm, Sat 10 am to 4 pm
Products: International premium chocolate
Special features: Hot chocolate, various events

Xocolaterie | 131

132 | Xocolaterie

Xocolaterie | 133

No.	Shop	Page
1	Alsterhaus	10
2	Andreas Linzner	16
3	Bethge Hamburg	20
4	Bettina Schoenbach Showroom	22
5	Bettina Schoenbach Store	26
6	Buchhandlung im Haus der Photographie	28
7	Cape Grace	30
8	craft2eu	32
9	DIESEL	34
10	Die Wäscherei	36
11	Elternhaus	42
12	Ermenegildo Zegna Shop Hamburg	46
13	Feldenkirchen – Men	48
14	Flamant	50
15	Frank Otto	52
16	Frischeparadies Goedeken	56
17	Grüne Flora	58
18	Hamburger Hof Parfümerie	62
19	Harald Lubner	64
20	Herr von Eden	66
21	Kuball&Kempe	70
22	Linette	74
23	Louis Vuitton	78
24	Marc Anthony Maß und Maßkonfektion	80
25	Montblanc	84
26	Olaf Thomas	90
27	Oschätzchen	94
28	Petra Teufel	98
29	Roomservice	100
30	Salon	104
31	T.A.T.E. tough against the elements	110
32	Tempel	112
33	Thorsten Lewin	116
34	Trittmacher	118
35	tulpen.design	120
36	Unger	124
37	Uniono by Shoes	128
38	Xocolaterie	130

135

COOL SHOPS

Size: 14 x 21.5 cm / 5 ½ x 8 ½ in.
136 pp
Flexicover
c. 130 color photographs
Text in English, German, French, Spanish and Italian

Other titles in the same series:

ISBN
3-8327-9073-X

ISBN
3-8327-9070-5

ISBN
3-8327-9121-3

ISBN
3-8327-9038-1

ISBN
3-8327-9071-3

ISBN
3-8327-9022-5

ISBN
3-8327-9072-1

ISBN
3-8327-9021-7

ISBN
3-8327-9037-3

ISBN
3-8327-9122-1

To be published in the same series:

Amsterdam
Dubai
Madrid
Miami

San Francisco
Shanghai
Singapore
Vienna

teNeues